✳ DEVOTIONAL COLORING

Meditations for Women

A COLORING BOOK FOR CONTEMPLATION

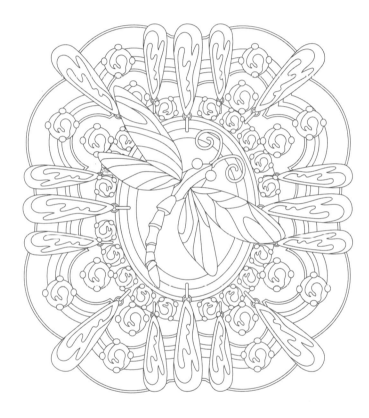

A Note from the Illustrator:

As I created the first few illustrations for this book, I considered adding a little signature to personalize it. I quickly realized the image of the cross symbolizes the purpose for these books; without the cross we have nothing. I've been incredibly blessed in my life and the opportunity to create visual scriptures has been a wonderful way to give the glory back to God. I hope you enjoy finding the small cross I incorporated into each illustration. To me, it's a literal example of "seek and ye shall find." If we look for the good, the joyful, and the happiness available to us through the grace of Christ, we will find it.

—Pam

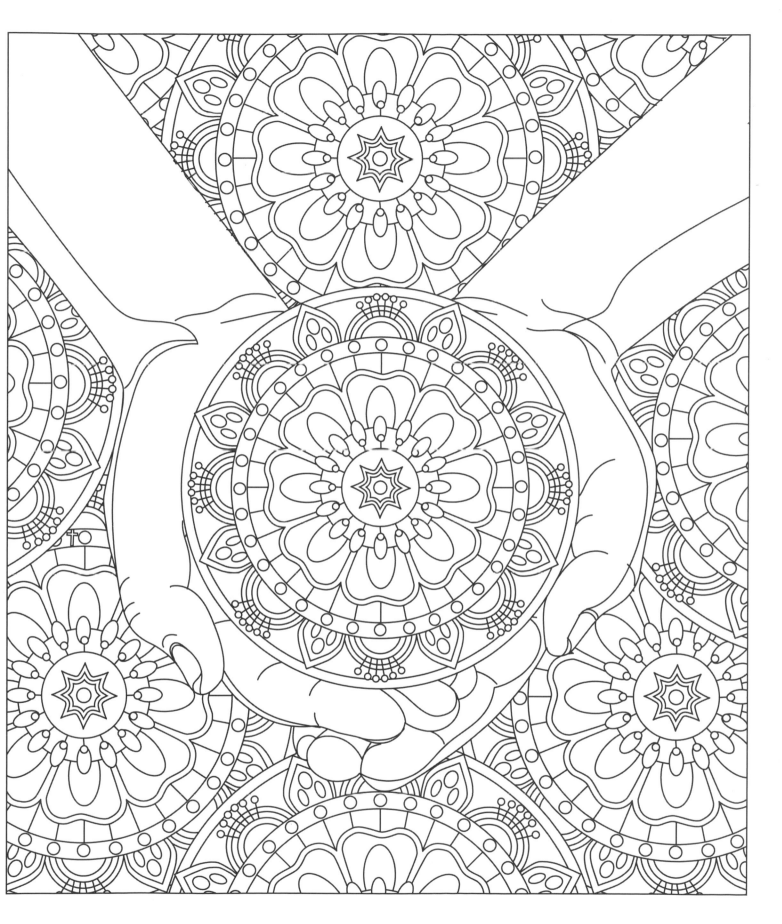

Let all your things be done with charity.
1 Corinthians 16:14

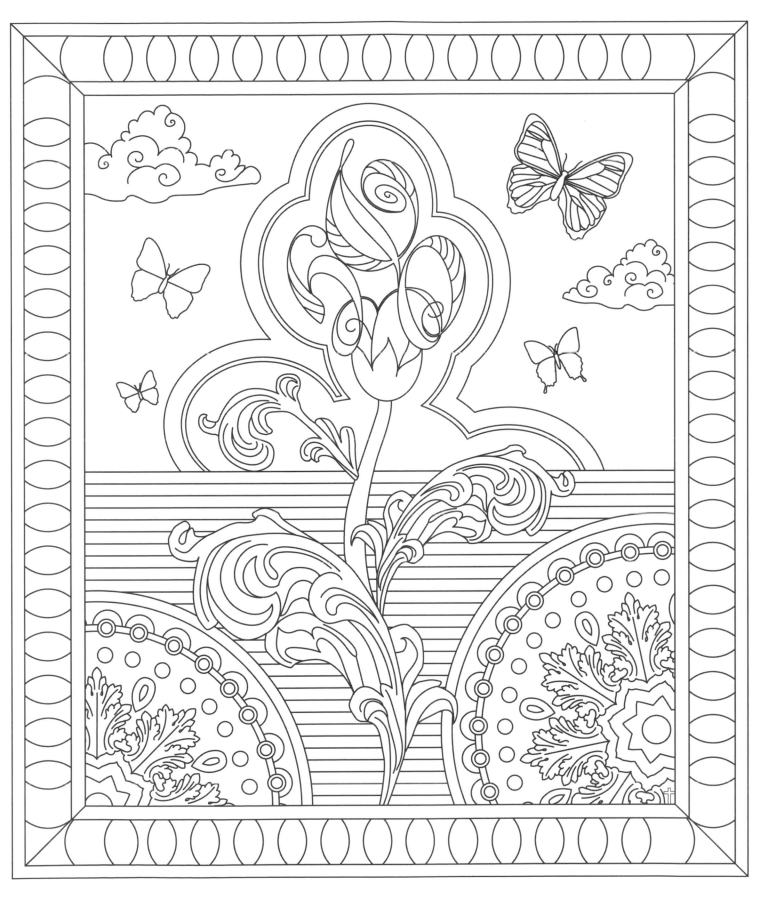

Beloved, let us love one another: for love is of God; and every one that loveth
is born of God, and knoweth God.

1 John 4:7

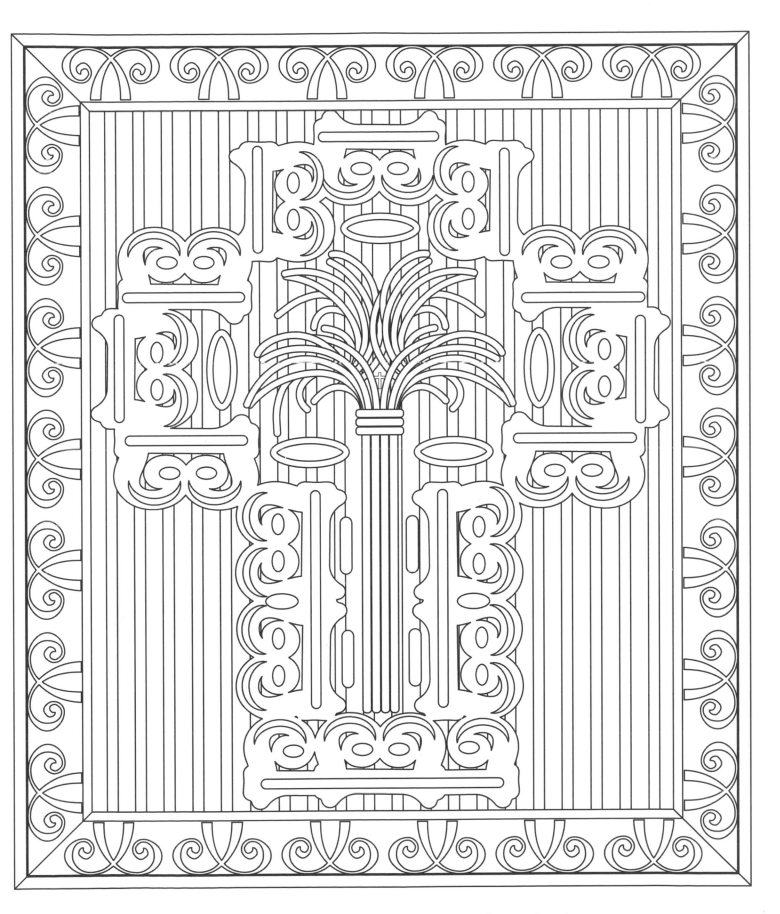

Behold, God [is] my salvation; I will trust, and not be afraid: for the LORD JEHOVAH
[is] my strength and [my] song; he also is become my salvation.

Isaiah 12:2

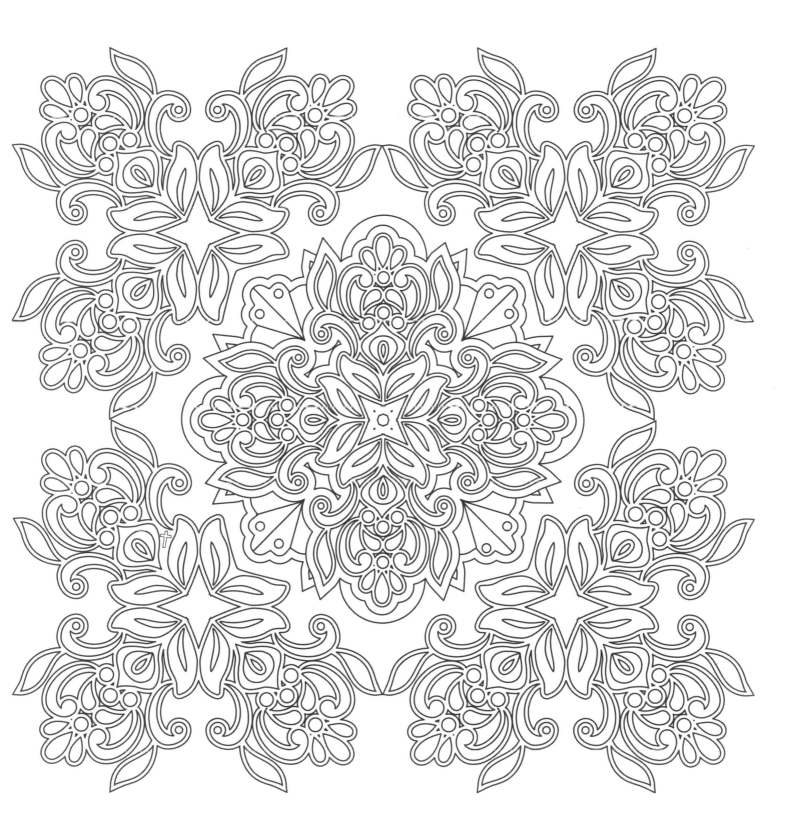

Rejoicing in hope; patient in tribulation; continuing instant in prayer;
Romans 12:12

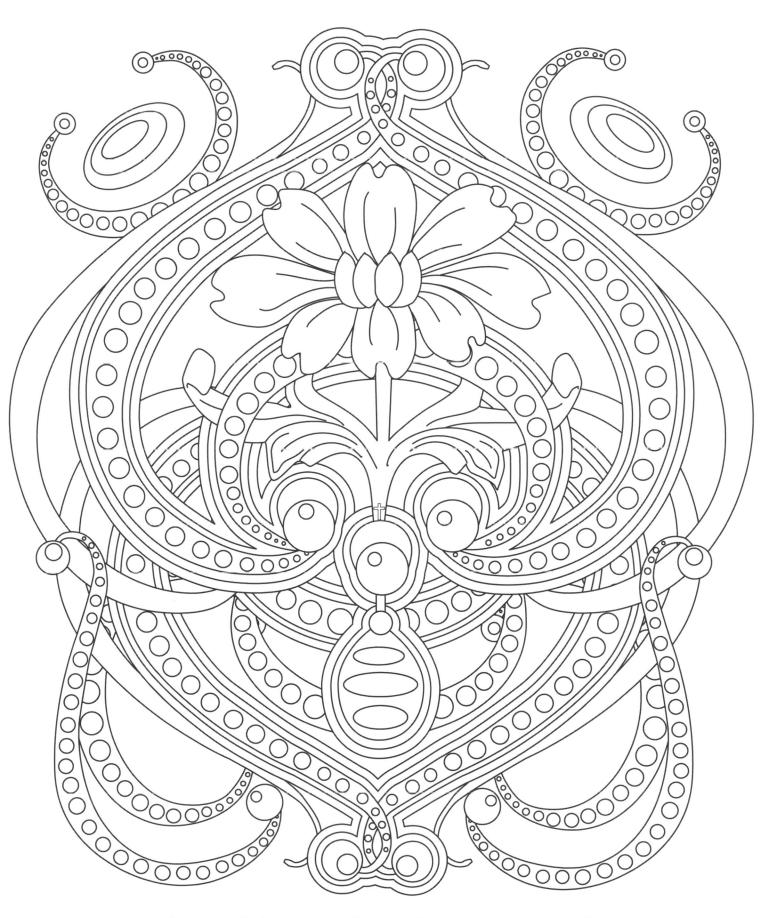

And above all things have fervent charity among yourselves:
for charity shall cover the multitude of sins.
1 Peter 4:8

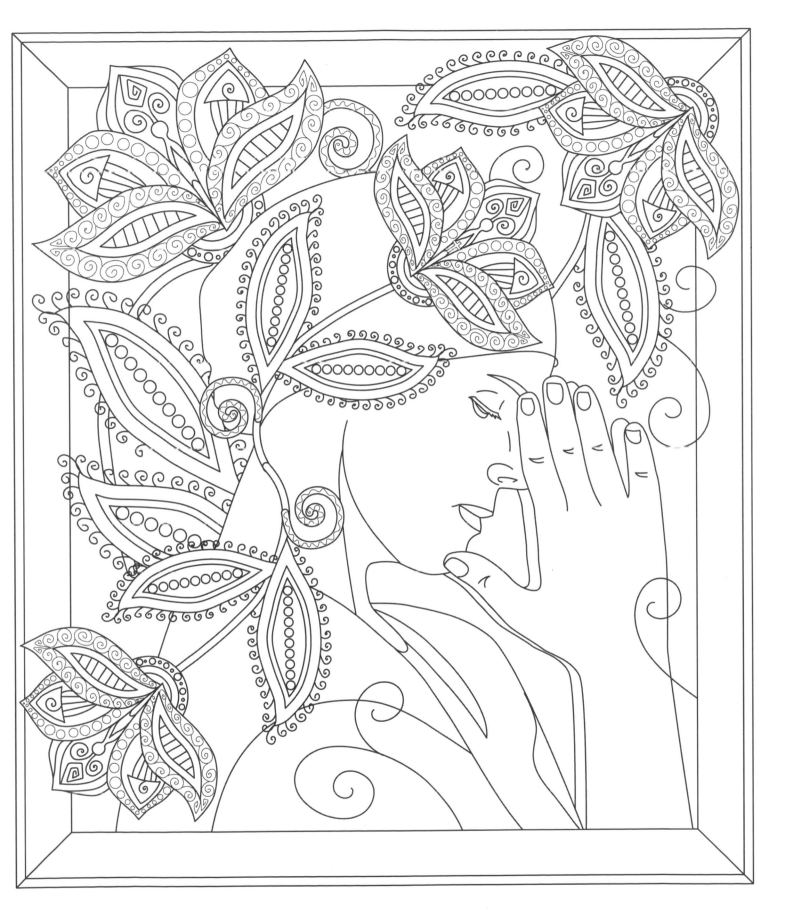

Heal me, O LORD, and I shall be healed; save me, and I shall be saved:
for thou [art] my praise.
Jeremiah 17:14

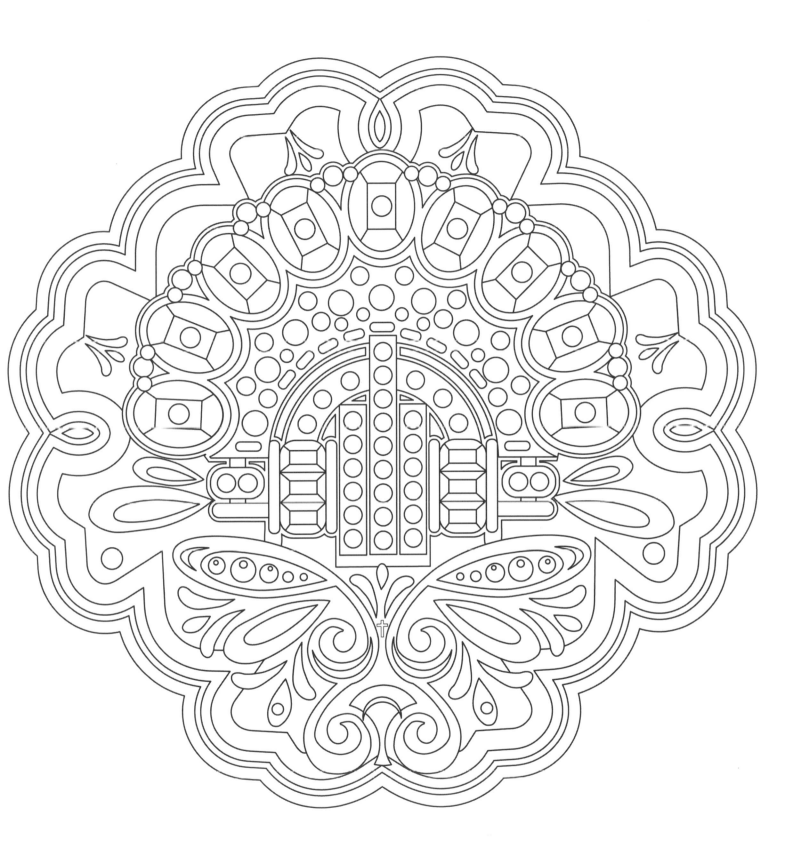

Commit thy way unto the LORD; trust also in him;
and he shall bring [it] to pass.
Psalms 37:5

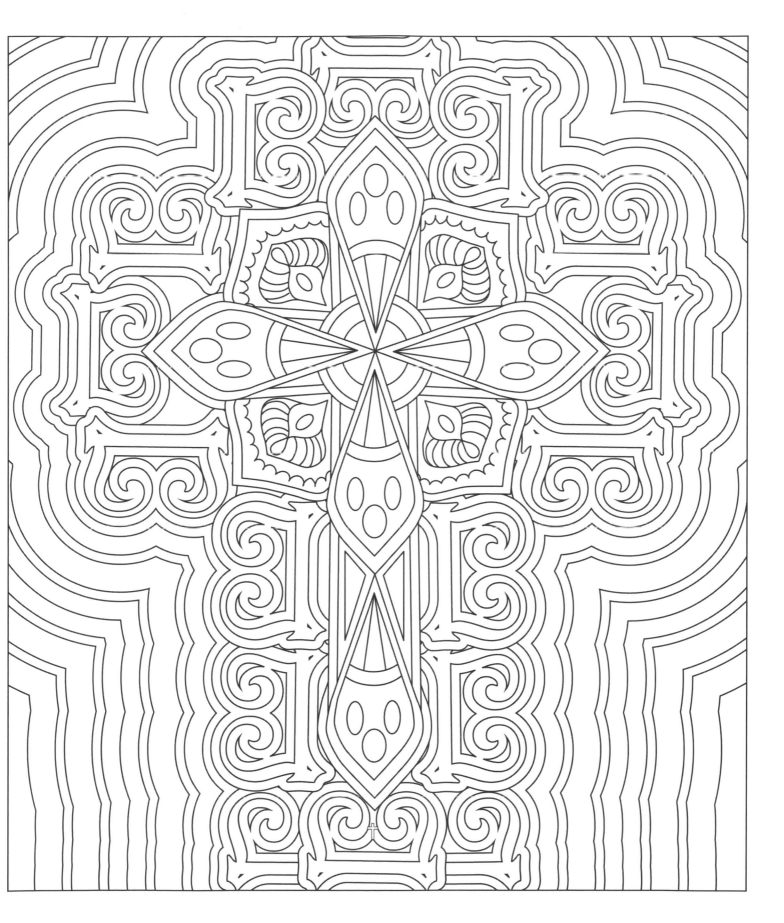

. . . Verily I say unto thee, today shalt thou be with me in paradise.
Luke 23:43

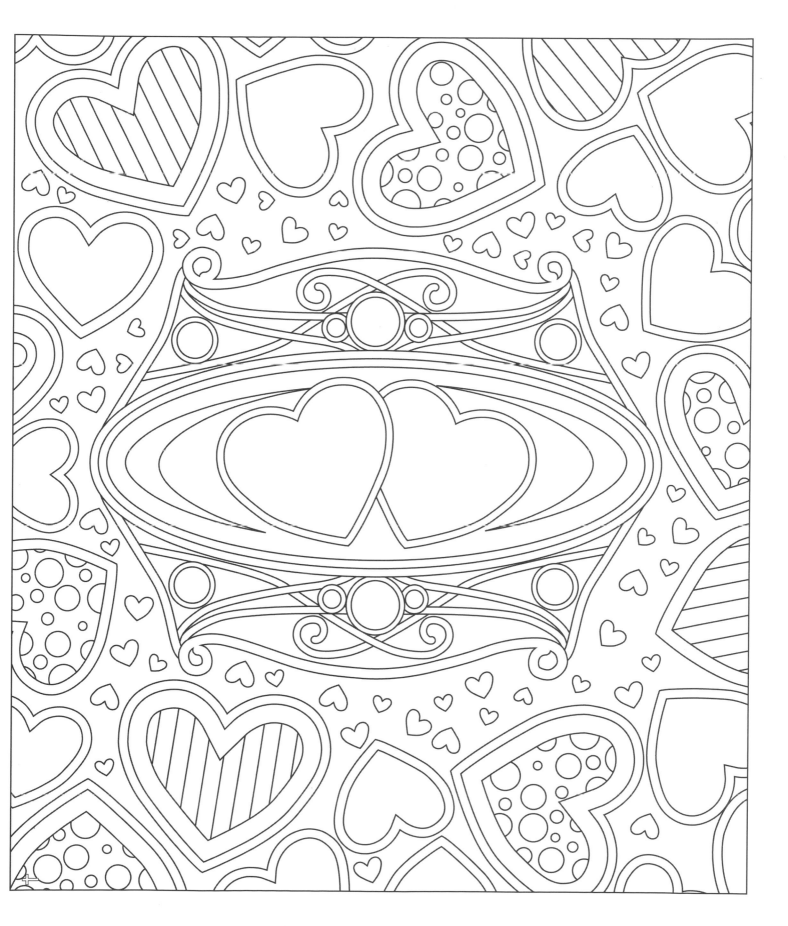

I am my beloved's, and my beloved is mine:
Song of Solomon 6:3

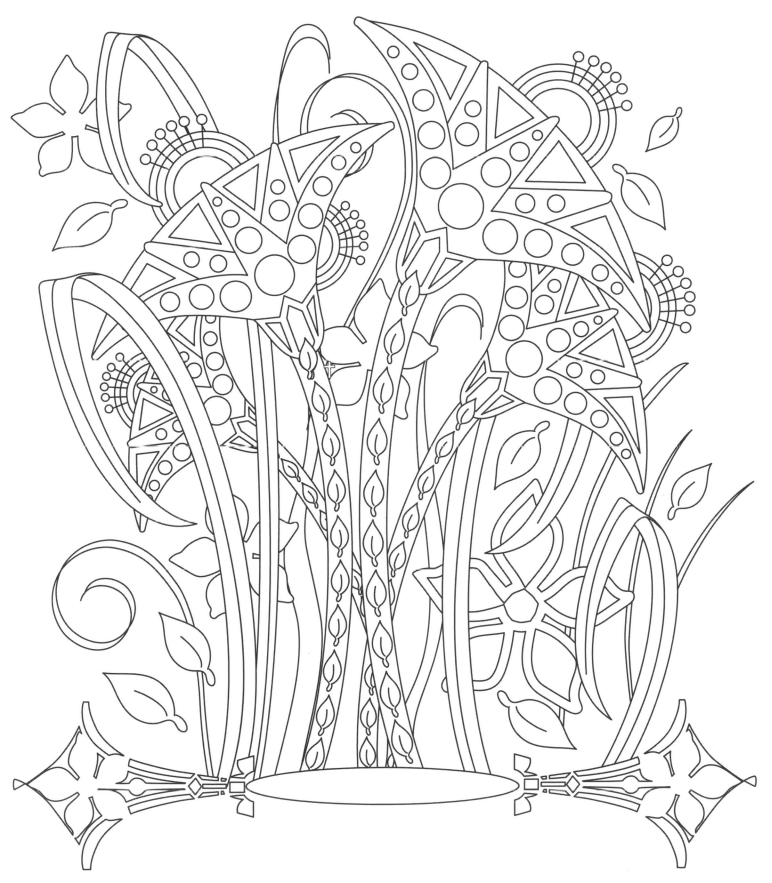

*And the LORD will take away from thee all sickness, and will put none
of the evil diseases of Egypt, which thou knowest, upon thee;
but will lay them upon all [them] that hate thee.*
Deuteronomy 7:15

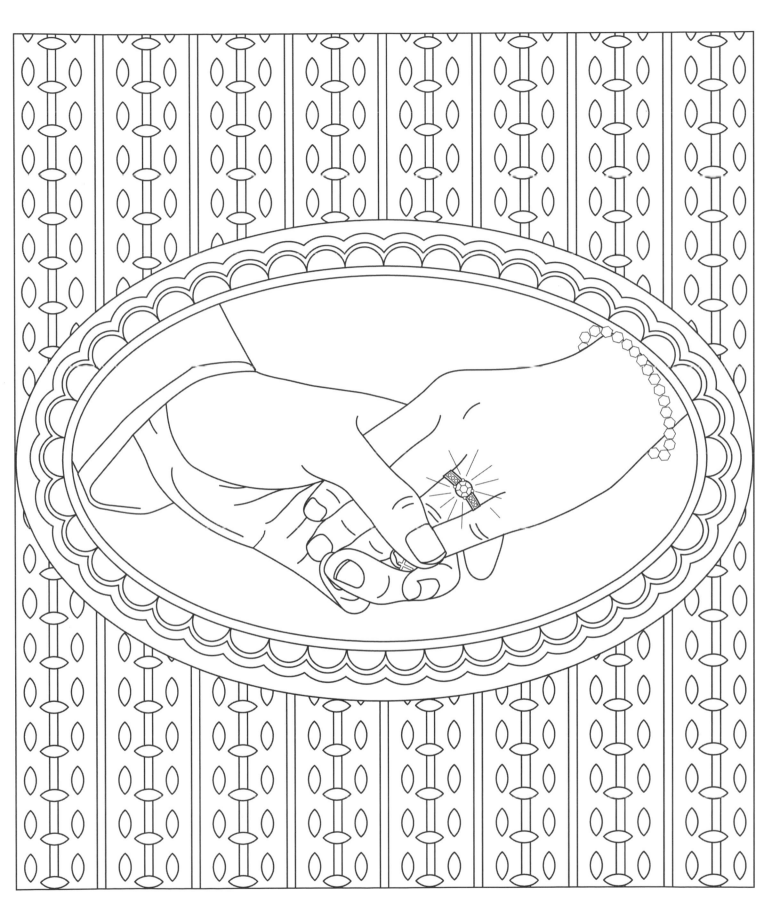

. . . a man leave his father and mother, and shall be joined unto his wife,
and they two shall be one flesh.
Ephesians 5:31

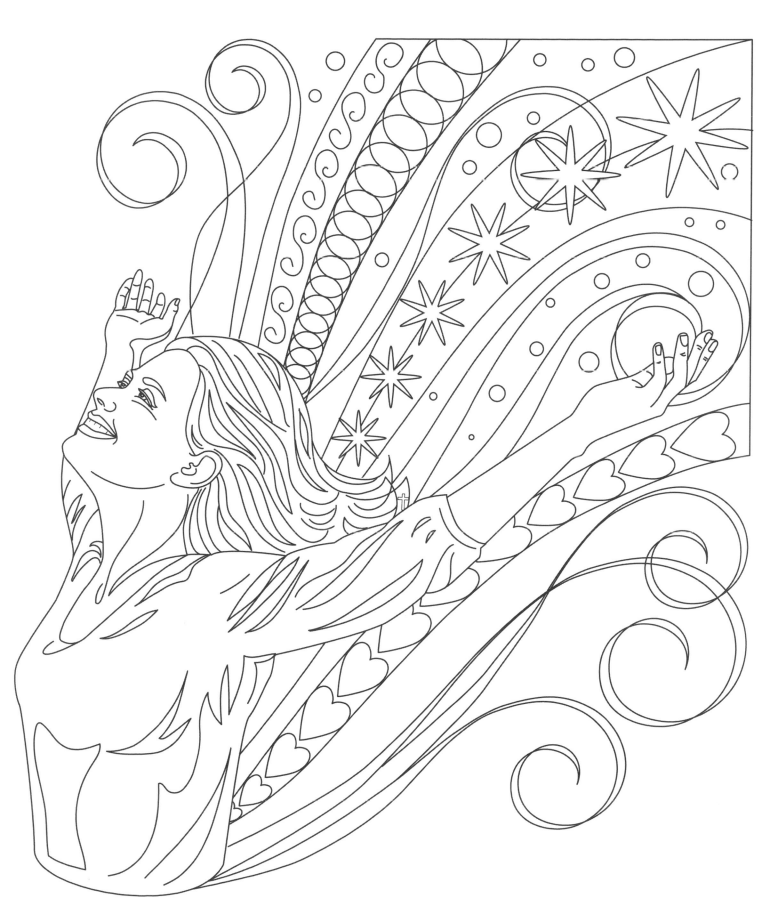

Now the God of hope fill you with all joy and peace in believing, that ye may abound in hope, through the power of the Holy Ghost.
Romans 15:13

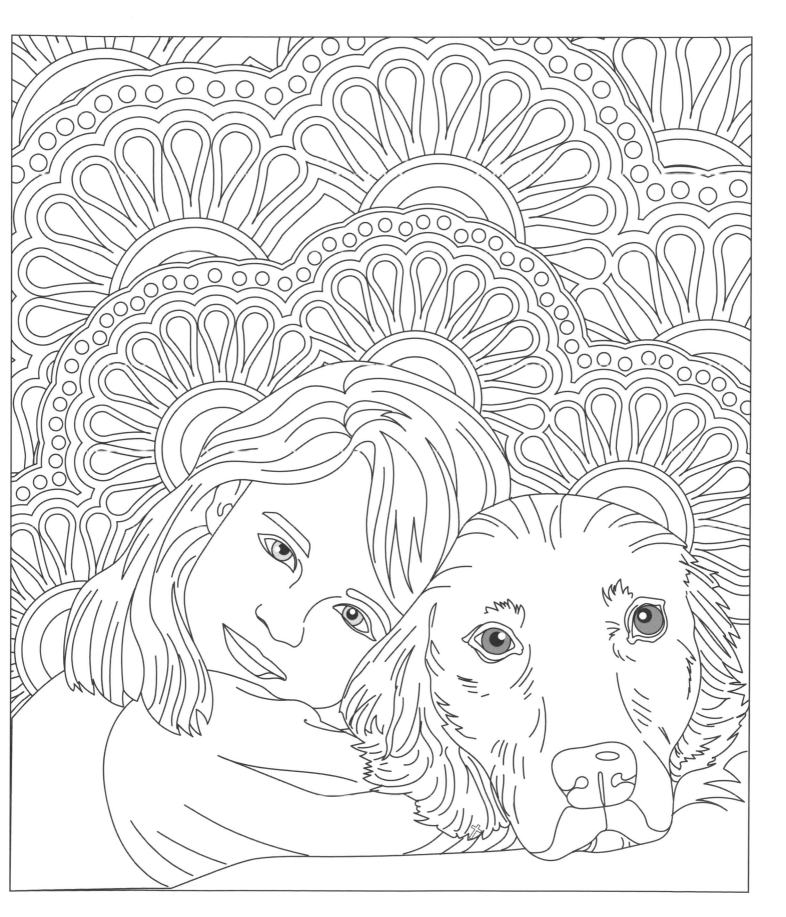

Fear thou not; for I [am] with thee: be not dismayed; for I [am] thy God: I will strengthen thee; yea, I will help thee; yea, I will uphold thee with the right hand of my righteousness.
Isaiah 41:10

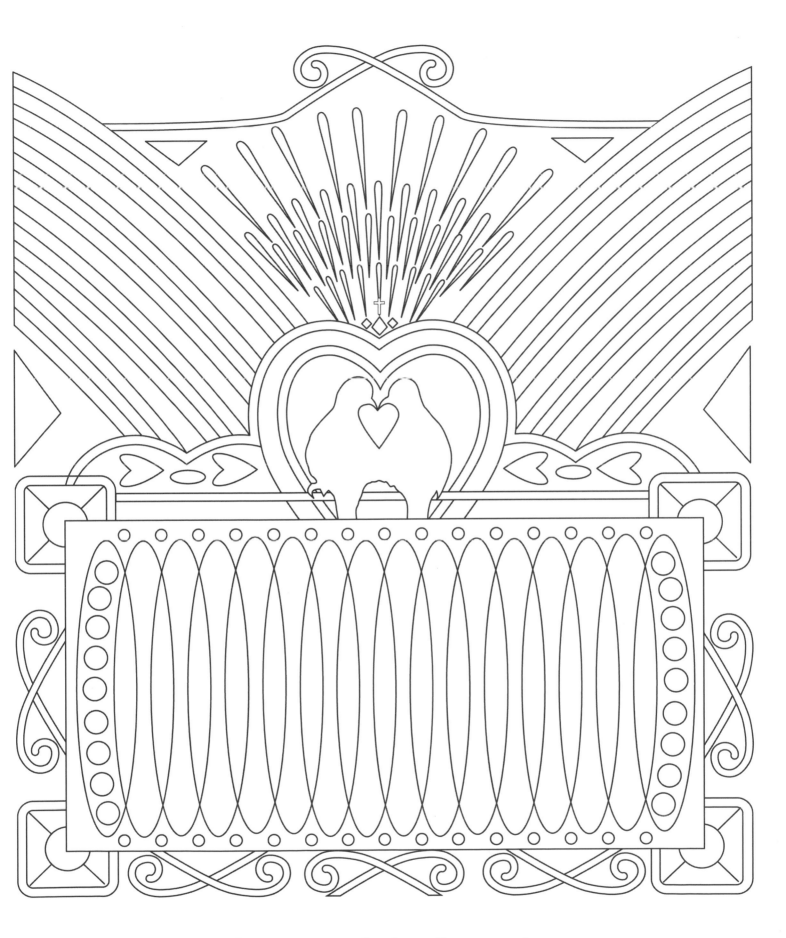

What time I am afraid, I will trust in thee.
Psalms 56:3-4

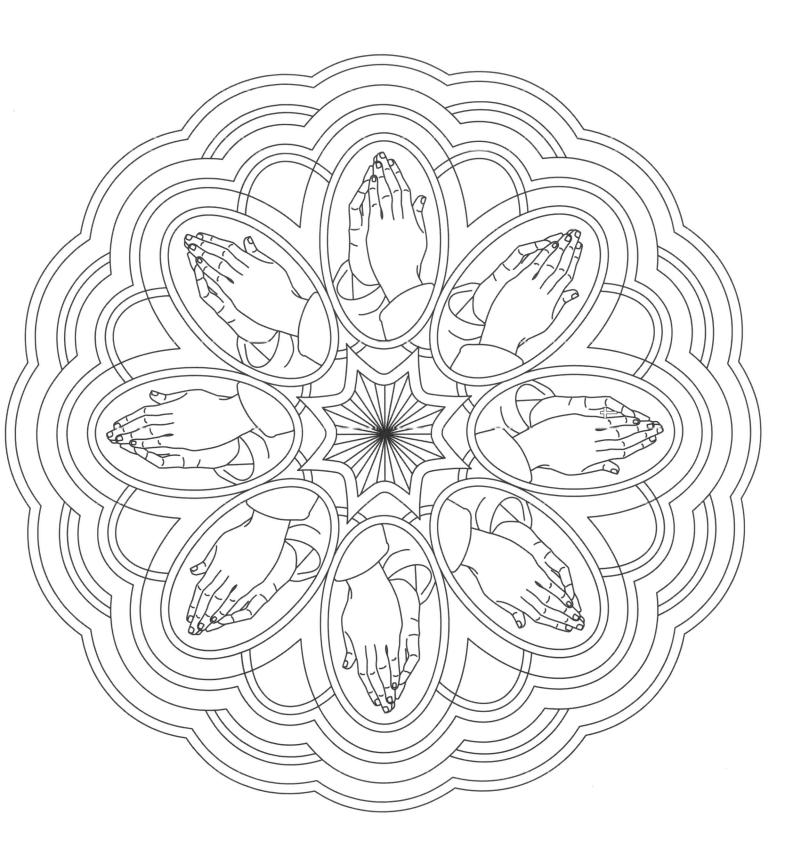

Confess [your] faults one to another, and pray one for another,
that ye may be healed.
James 5:16

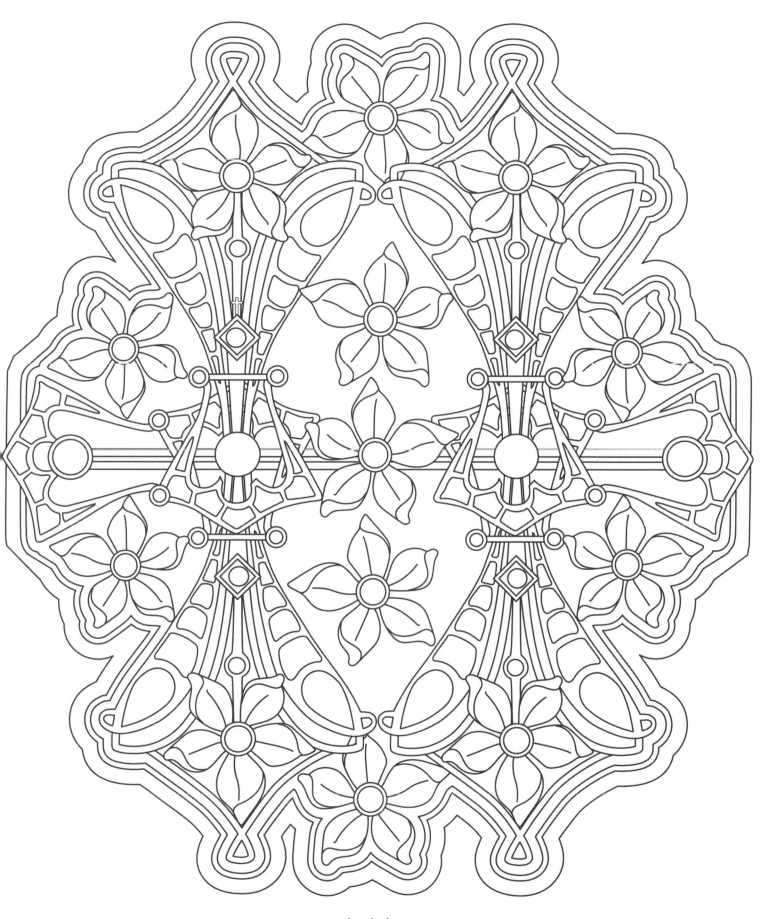

But I say unto you which hear, Love your enemies,
do good to them which hate you,
Luke 6:27

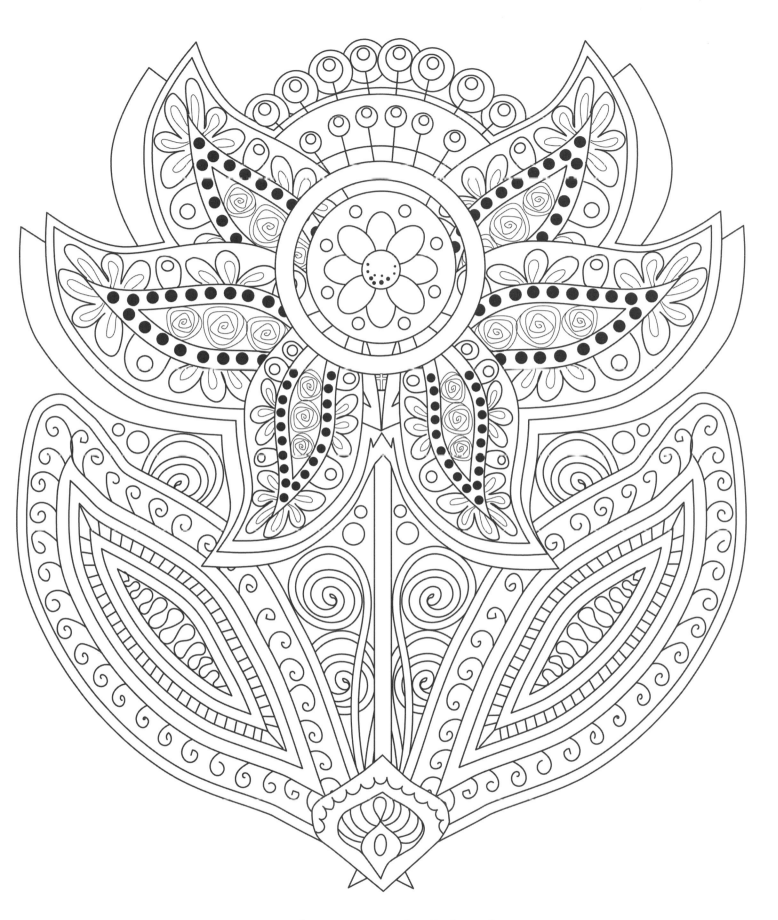

Trust in the LORD with all thine heart;
and lean not unto thine own understanding.
Proverbs 3:5

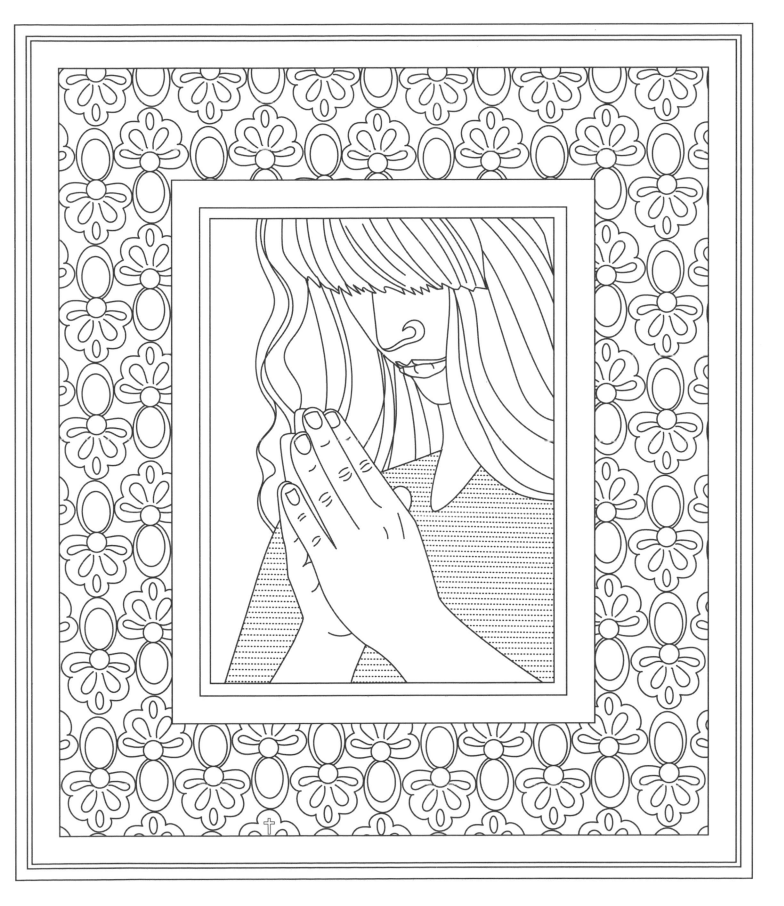

*Be of good courage, and he shall strengthen your heart,
all ye that hope in the LORD.*
Psalms 31:24

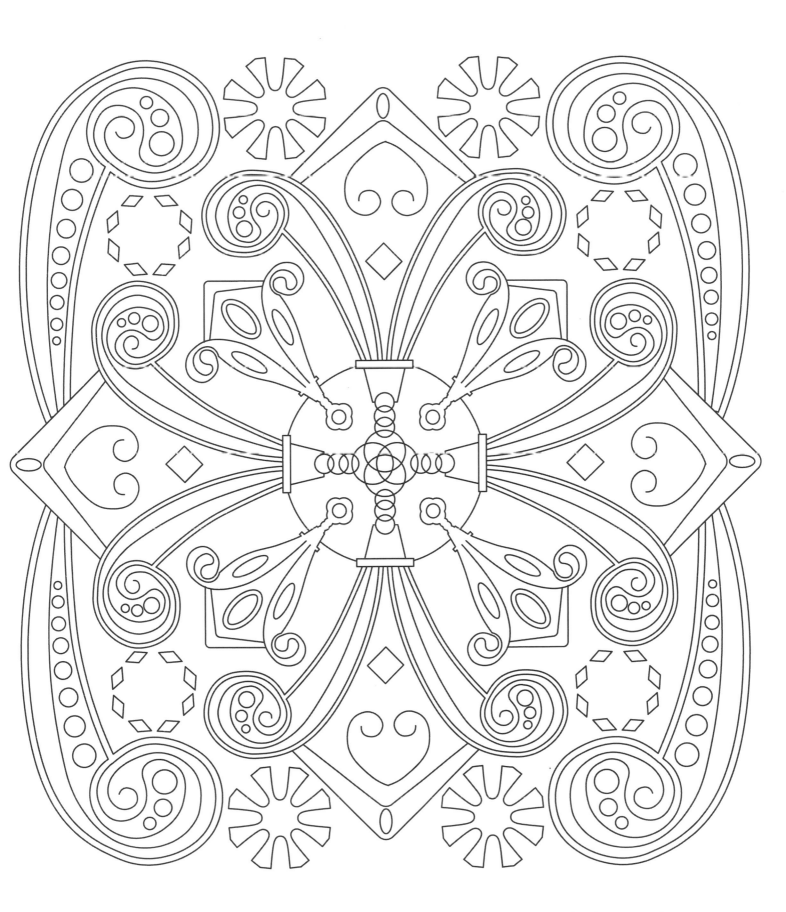

But he giveth more grace. Wherefore he saith, God resisteth the proud,
but giveth grace unto the humble.
James 4:6

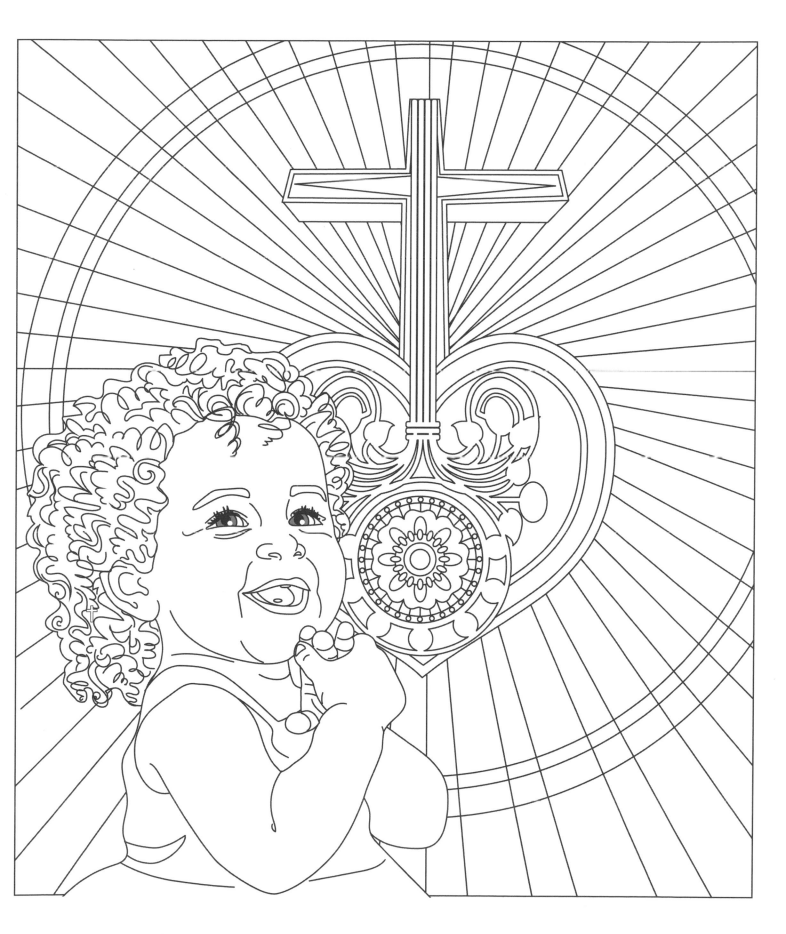

In all thy ways acknowledge him, and he shall direct thy paths.
Proverbs 3:6

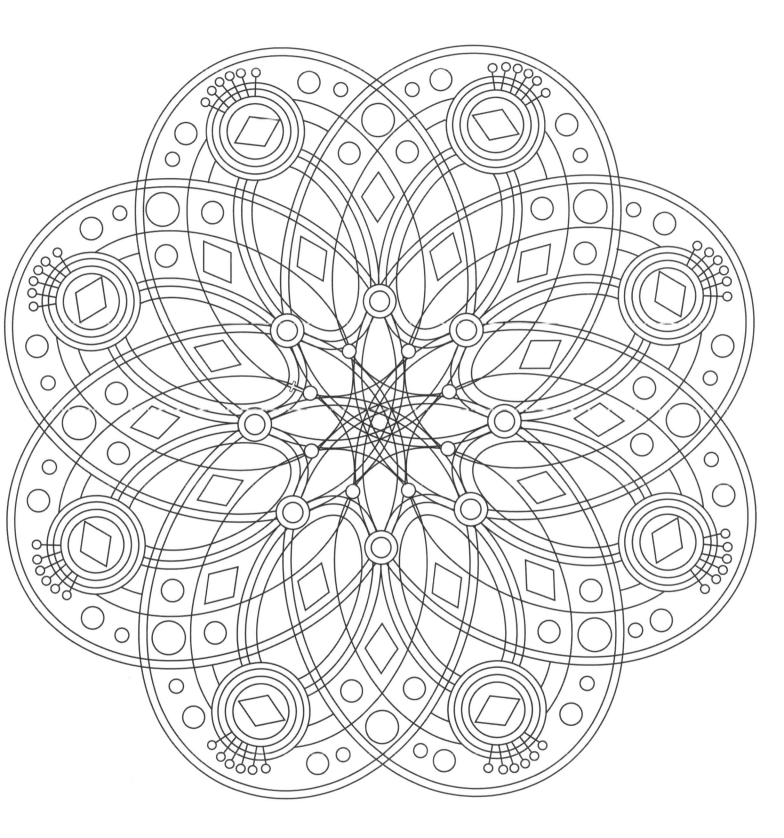

Judge not, and ye shall not be judged: condemn not,
and ye shall not be condemned: forgive, and ye shall be forgiven:
Luke 6:37

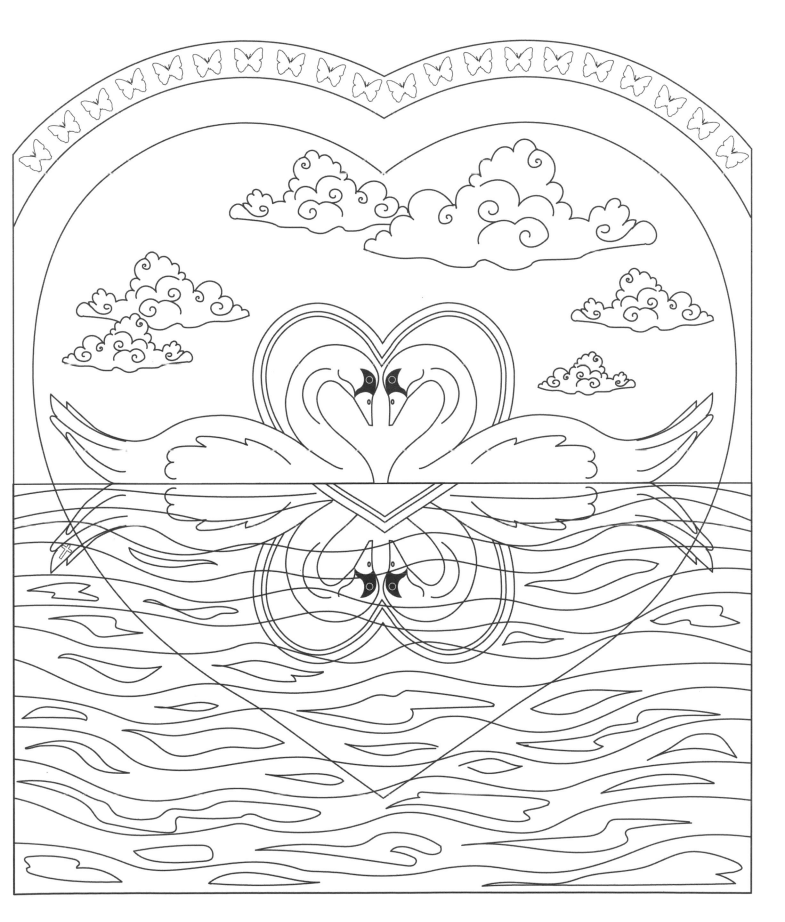

Many waters cannot quench love, neither can the floods drown it:
Song of Solomon 8:7

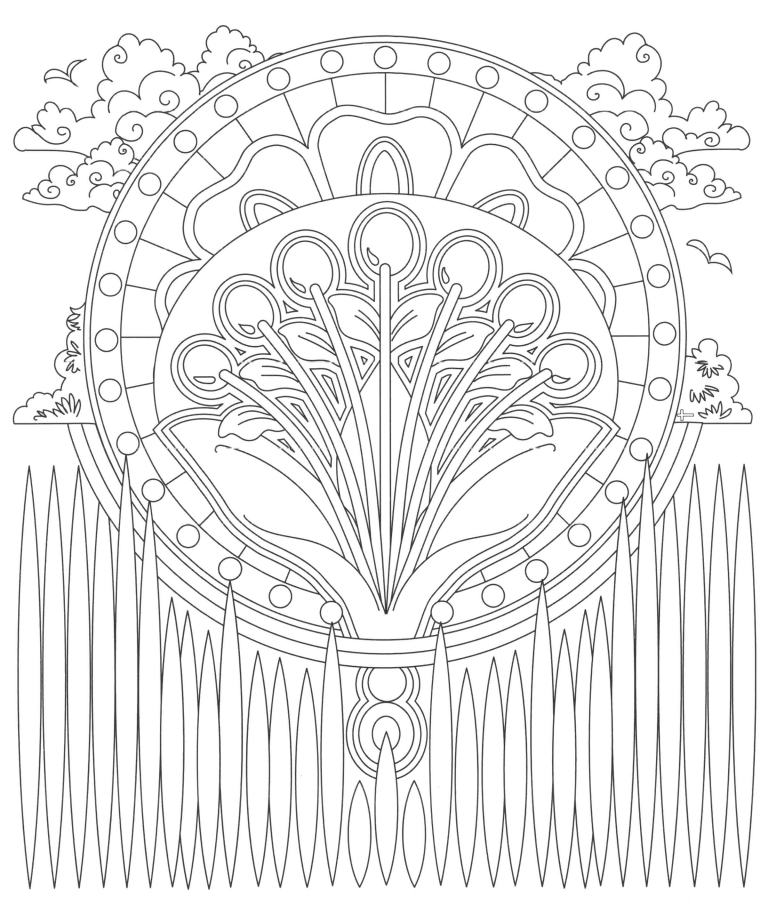

Beloved, I wish above all things that thou mayest prosper and be in health, even as thy soul prospereth.

3 John 1:2

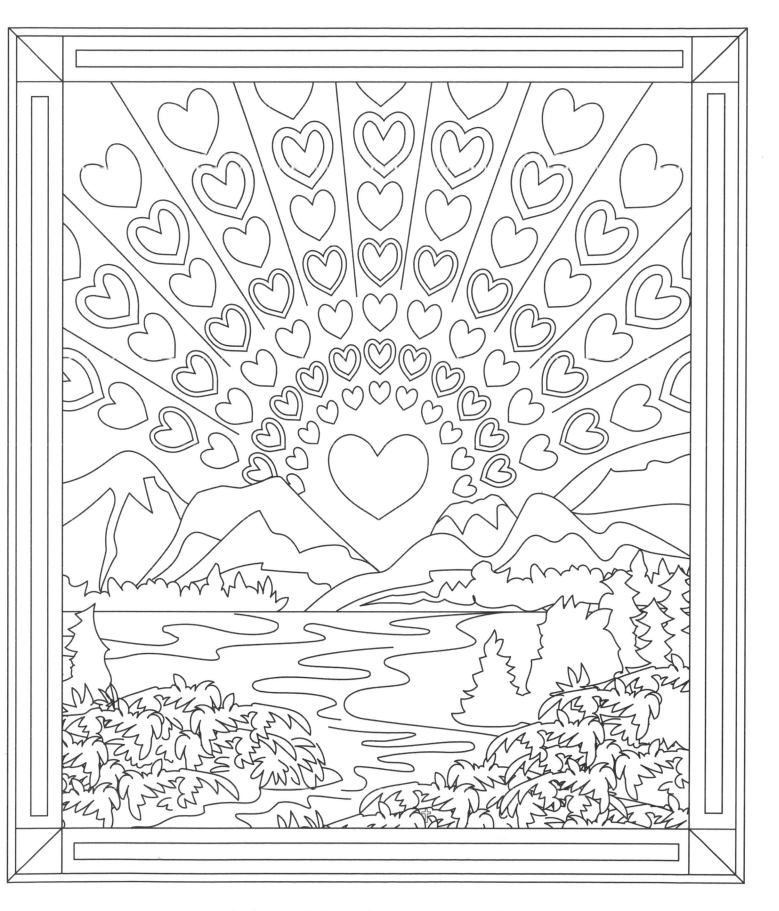

And above all these things [put on] charity,
which is the bond of perfectness.
Colossians 3:14

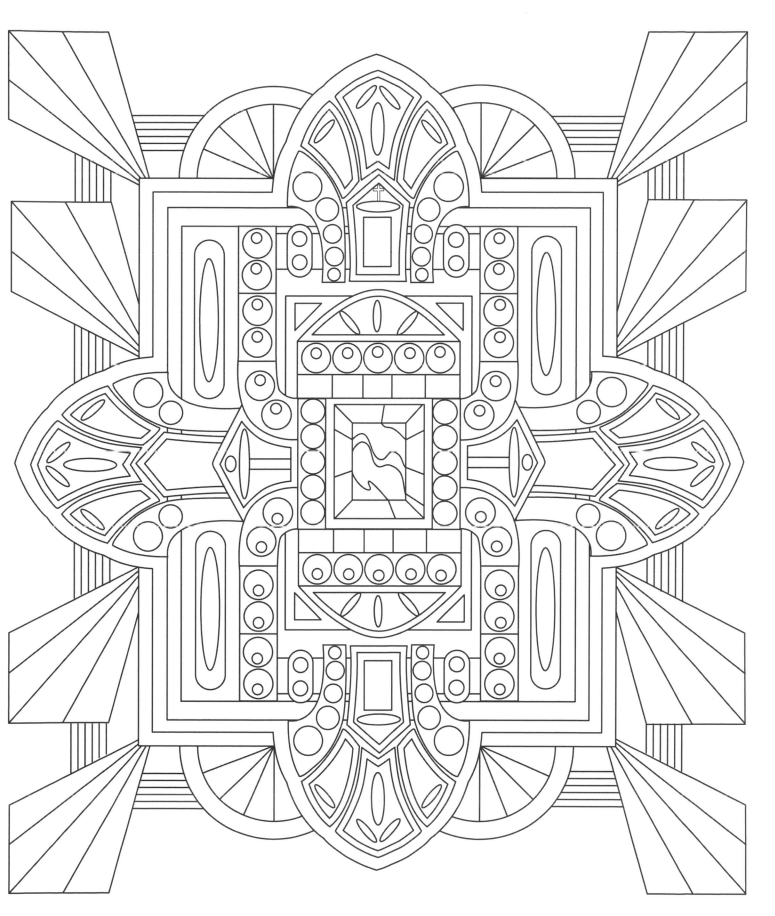

Let us therefore come boldly unto the throne of grace, that we may obtain mercy, and find grace to help in time of need.

Hebrews 4:16

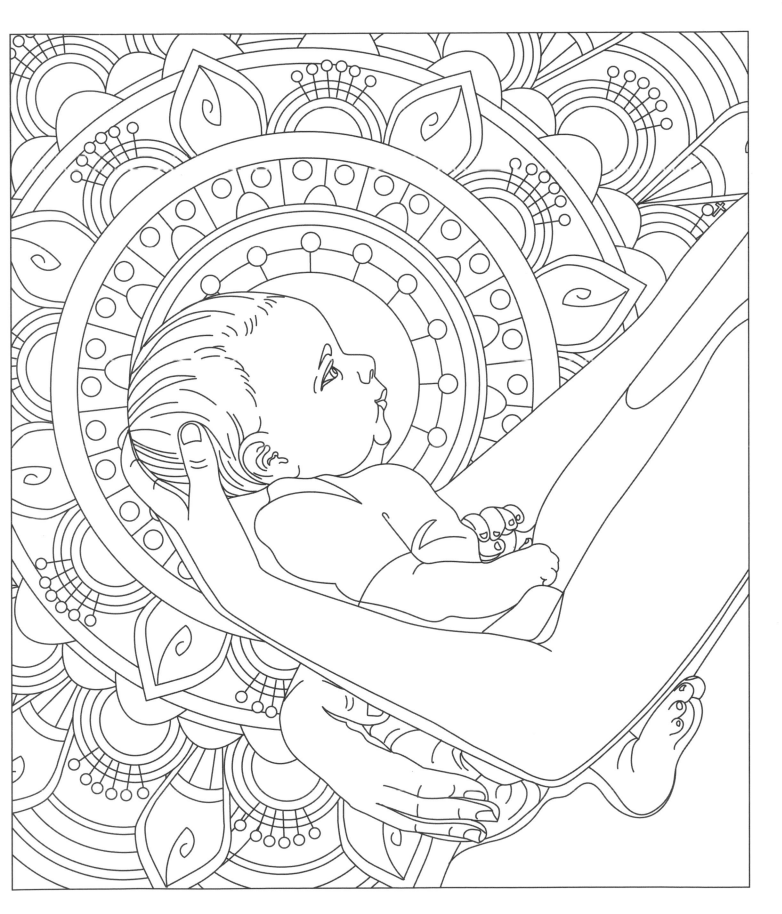

*Lo, children [are] an heritage of the LORD: [and] the fruit
of the womb [is his] reward.*
Psalms 127:3

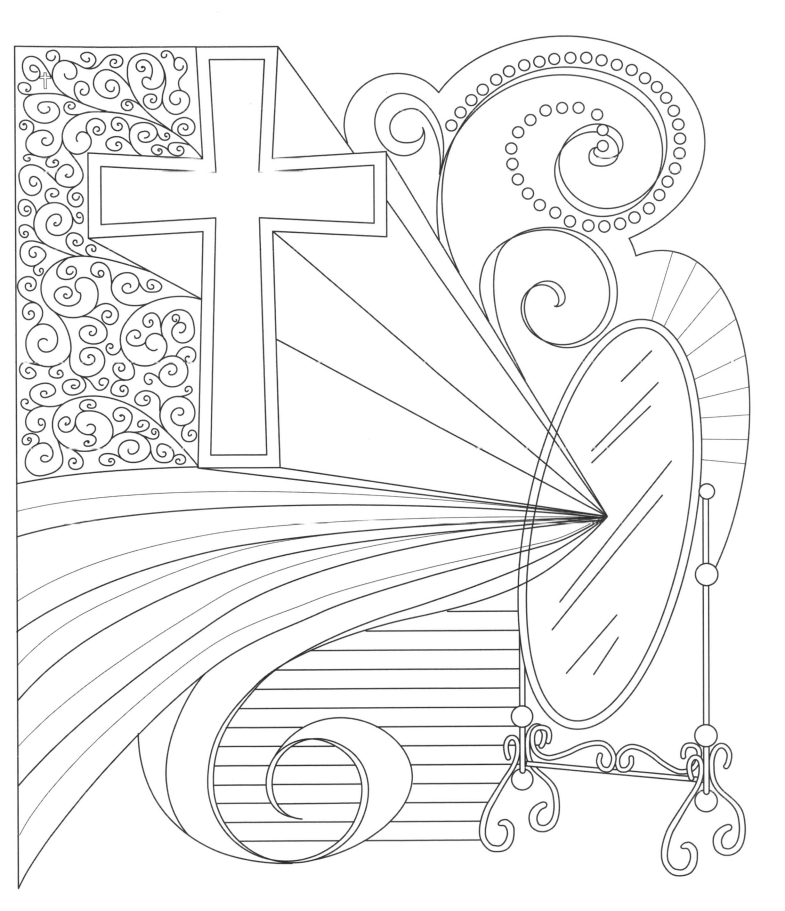

*Favor [is] deceitful, and beauty [is] vain: [but] a woman [that] feareth
the LORD, she shall be praised.*
Proverbs 31:30-31

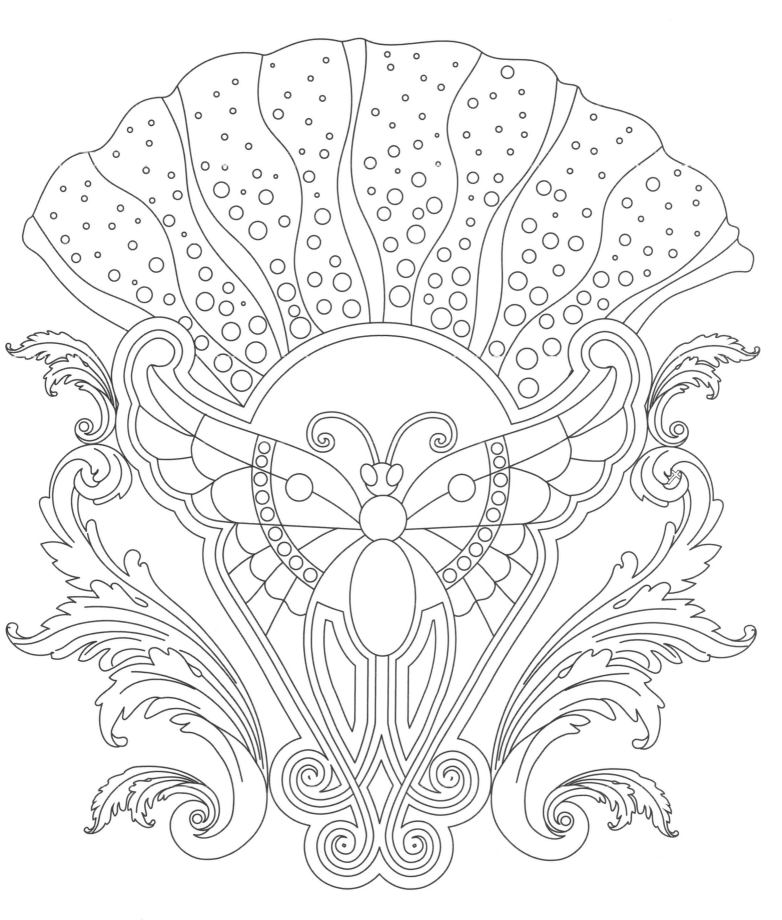

Strength and honor [are] her clothing; and she shall rejoice in time to come.
Proverbs 31:25

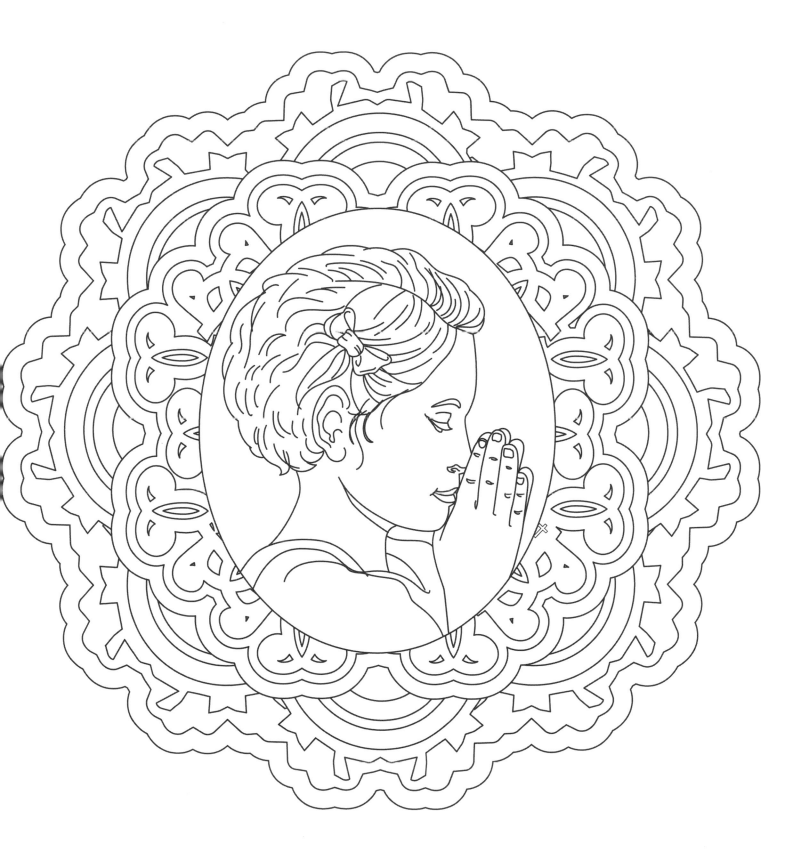

For ye are all the children of God by faith in Christ Jesus.
Galatians 3:26-29

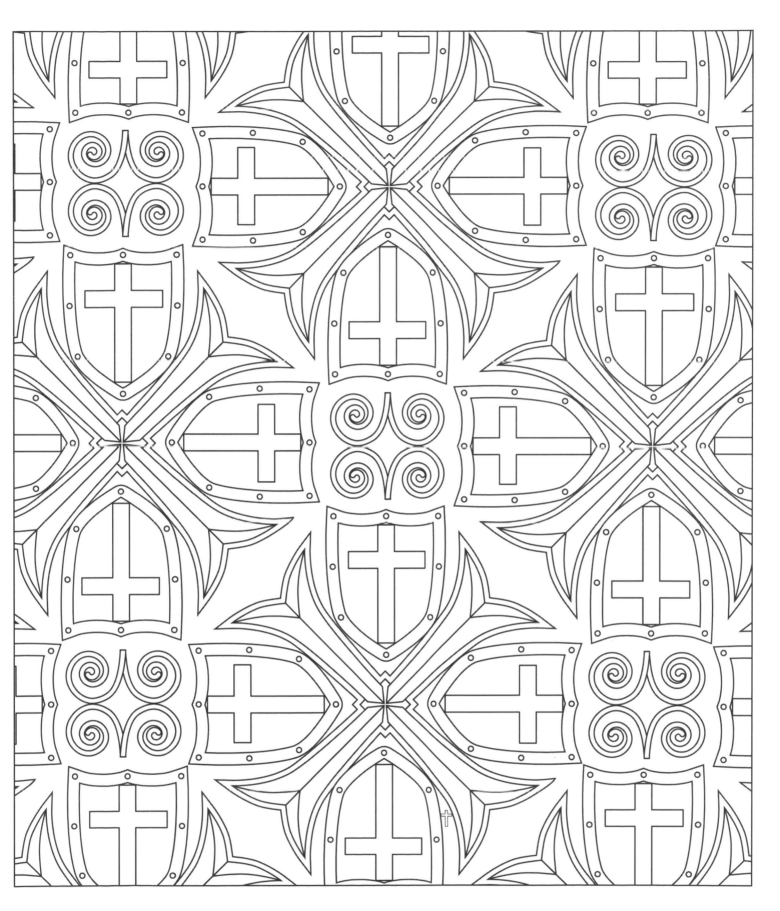

For the LORD your God [is] he that goeth with you, to fight
for you against your enemies, to save you.
Deuteronomy 20:4

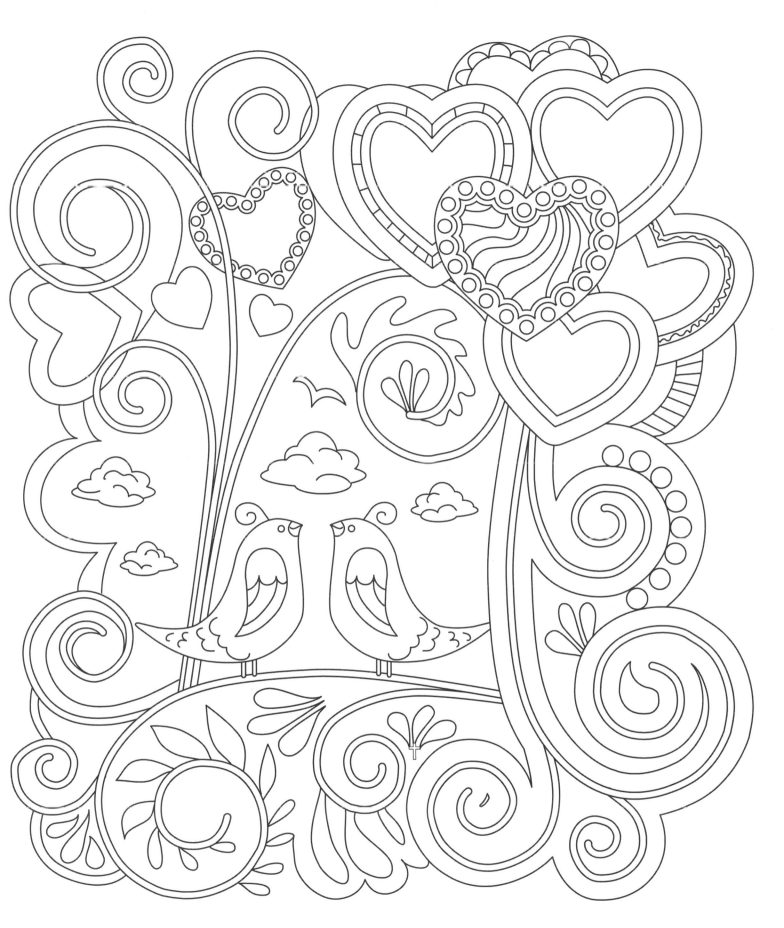

A merry heart doeth good [like] a medicine:
but a broken spirit drieth the bones.

Proverbs 17:22

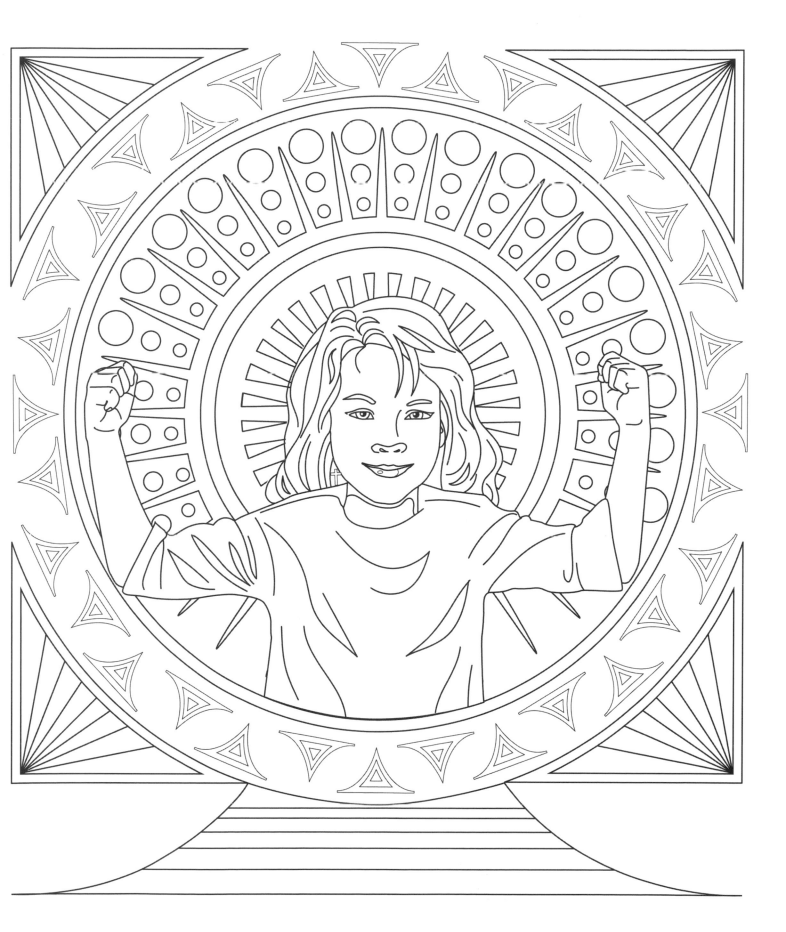

I can do all things through Christ which strengtheneth me.
Philippians 4:13

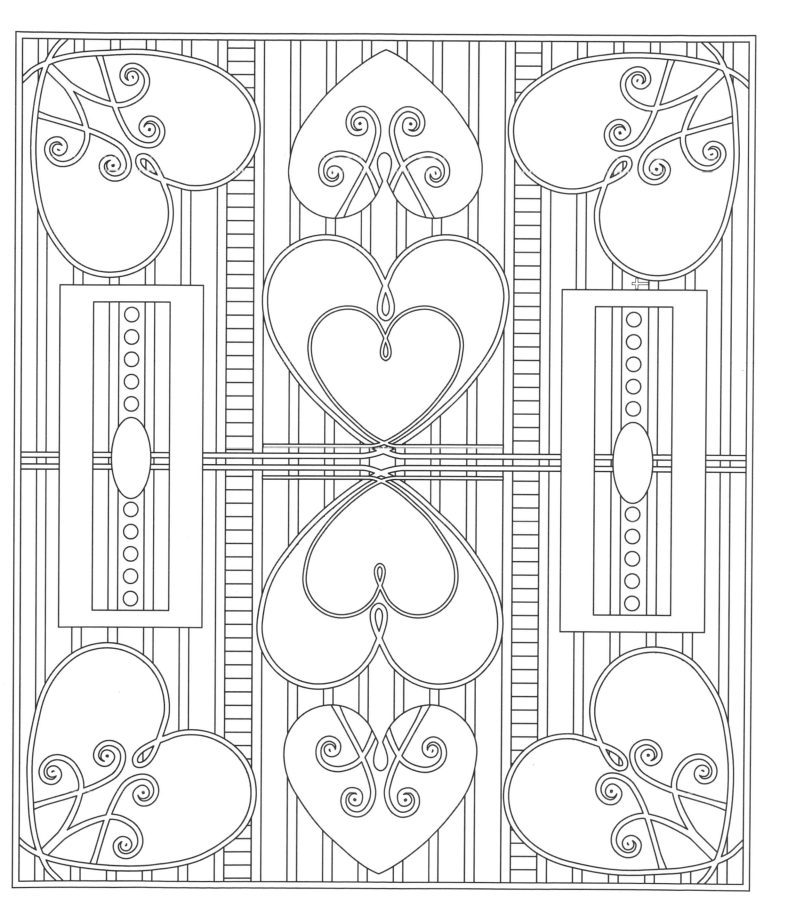

And be ye kind one to another, tenderhearted, forgiving one another,
even as God for Christ's sake hath forgiven you.
Ephesians 4:32

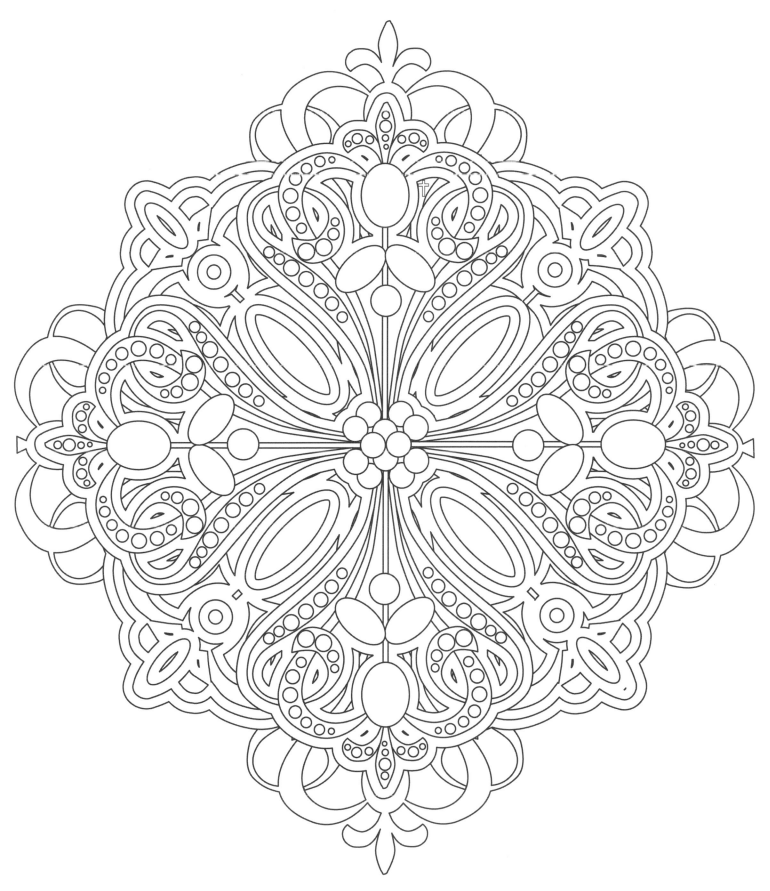

And God shall wipe away all tears from their eyes; and there shall be no more death, neither sorrow, nor crying, neither shall there be any more pain: for the former things are passed away.

Revelation 21:4

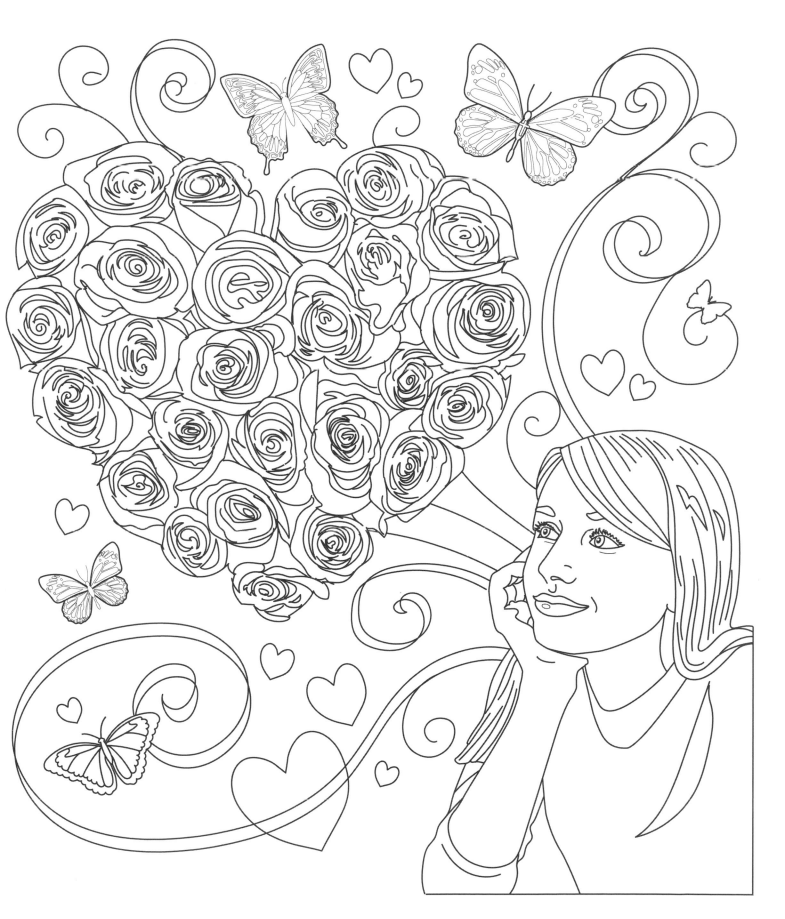

There is no fear in love; but perfect love casteth out fear: because fear hath torment.
He that feareth is not made perfect in love.

1 John 4:18

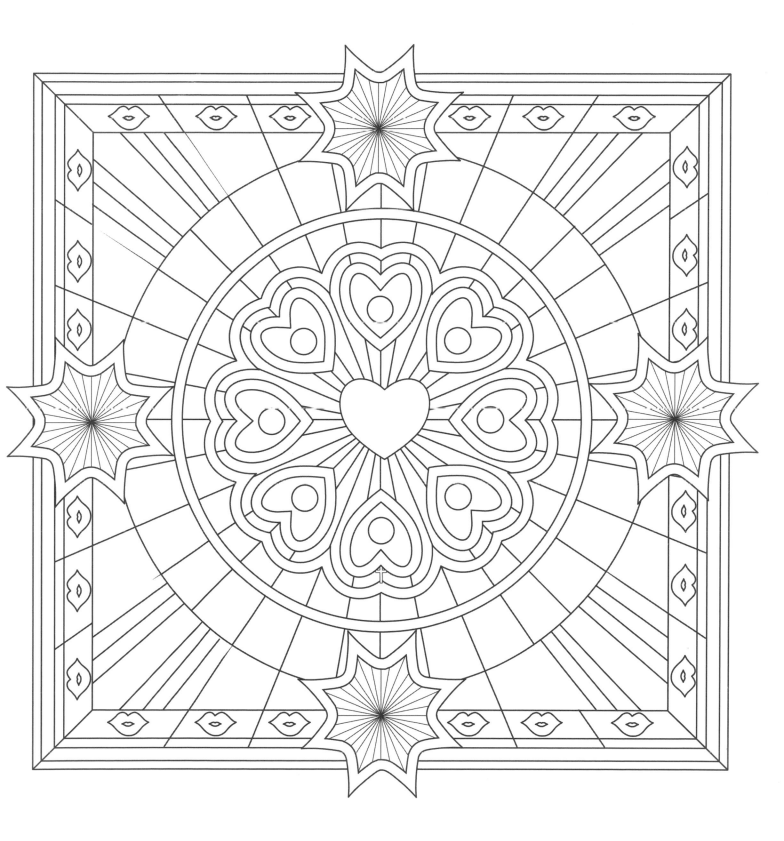

Let him kiss me with the kisses of his mouth:
for thy love is better than wine.
Song of Solomon 1:2

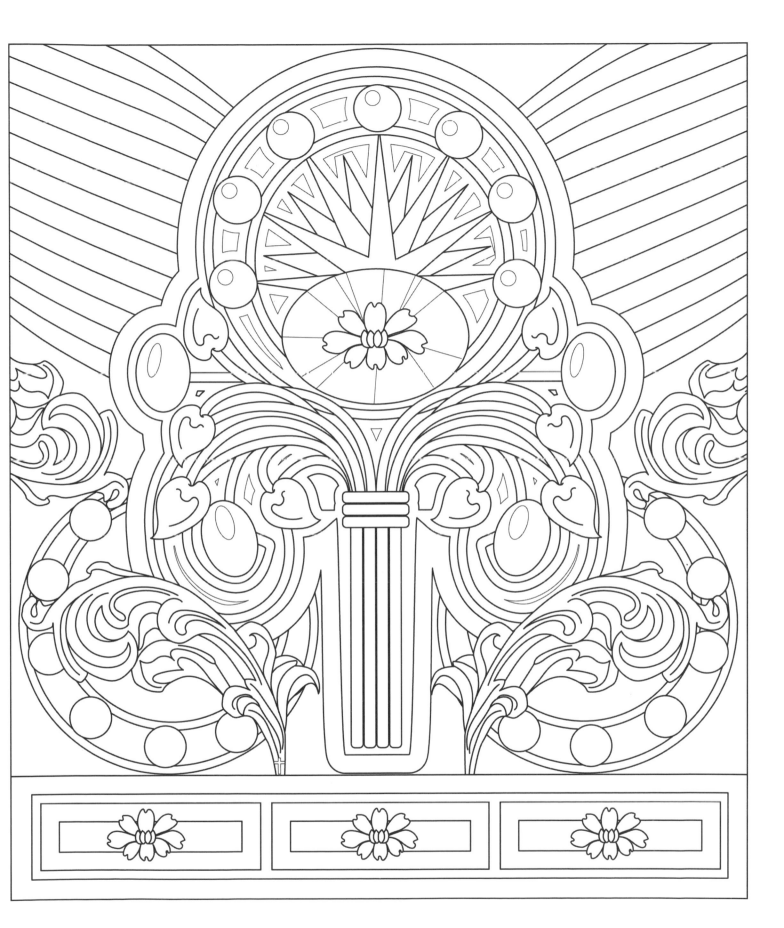

Many daughters have done virtuously, but thou excellest them all.
Proverbs 31:29

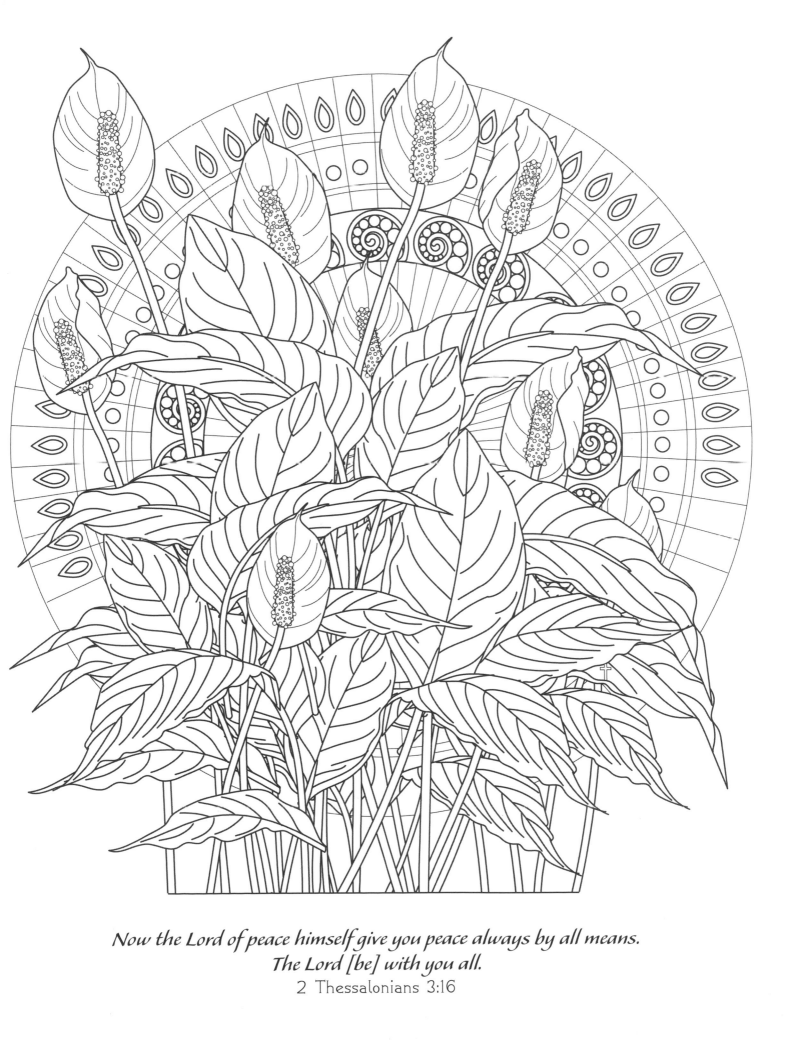

Now the Lord of peace himself give you peace always by all means.
The Lord [be] with you all.
2 Thessalonians 3:16

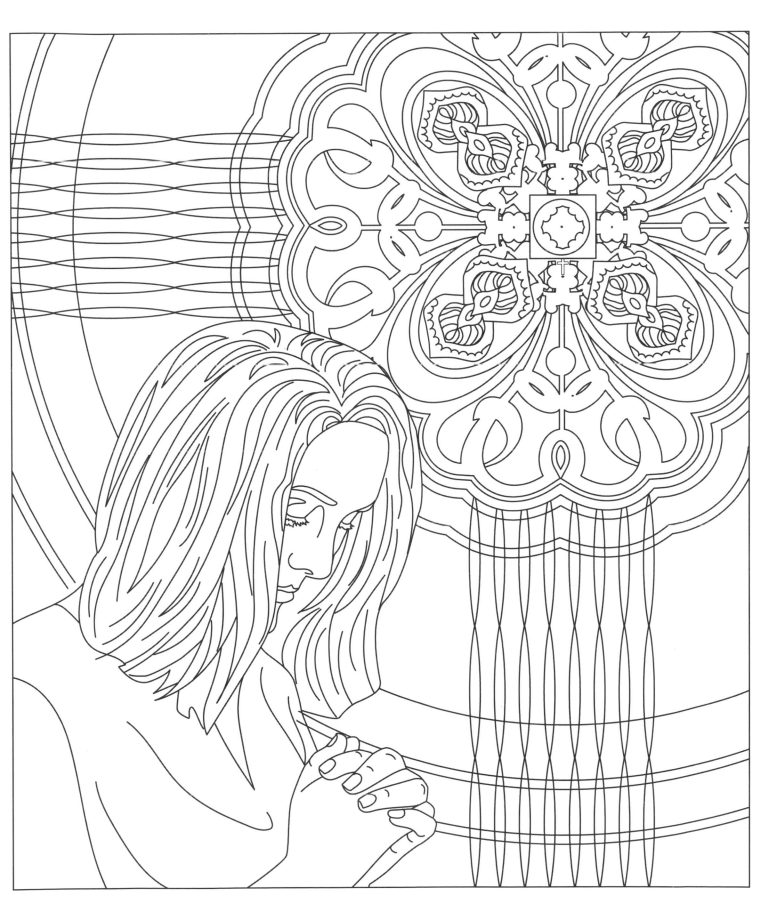

*If we confess our sins, he is faithful and just to forgive us [our] sins,
and to cleanse us from all unrighteousness.*

1 John 1:9

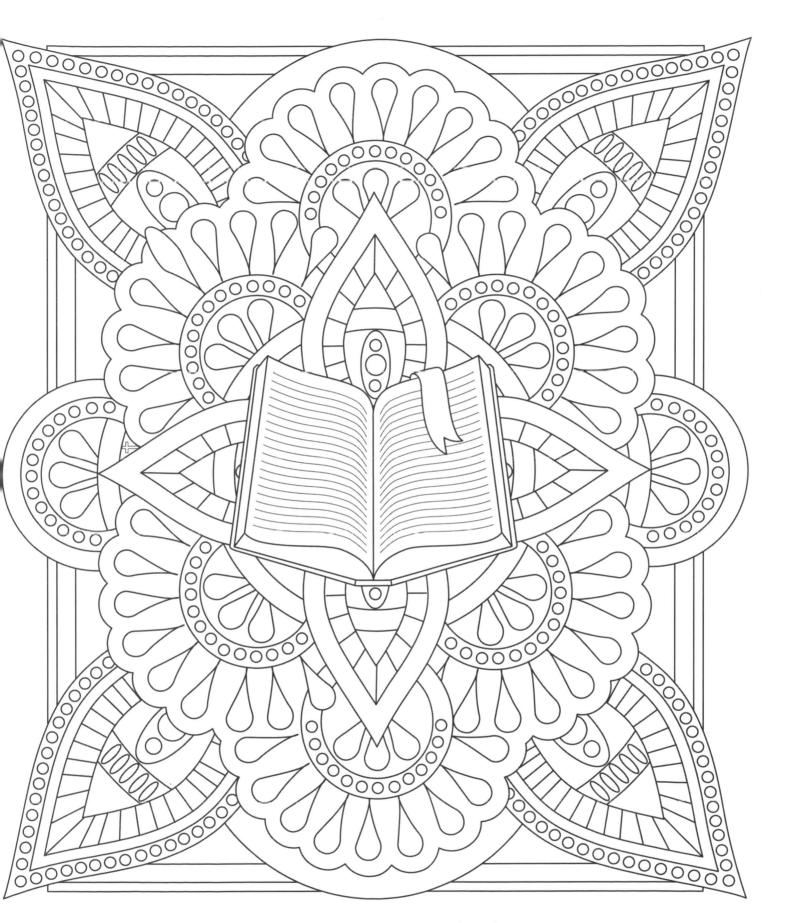

And all thy children [shall be] taught of the LORD;
and great [shall be] the peace of thy children.
Isaiah 54:13

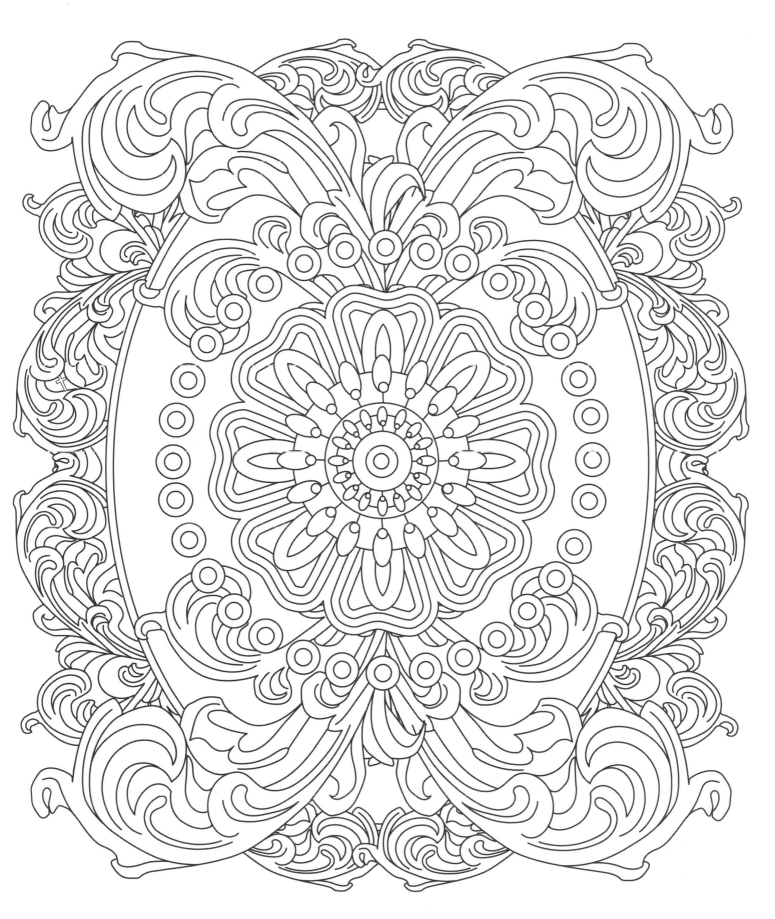

Be strong and of a good courage, fear not, nor be afraid of them: for the LORD thy God,
he [it is] that doth go with thee; he will not fail thee, nor forsake thee.
Deuteronomy 31:6

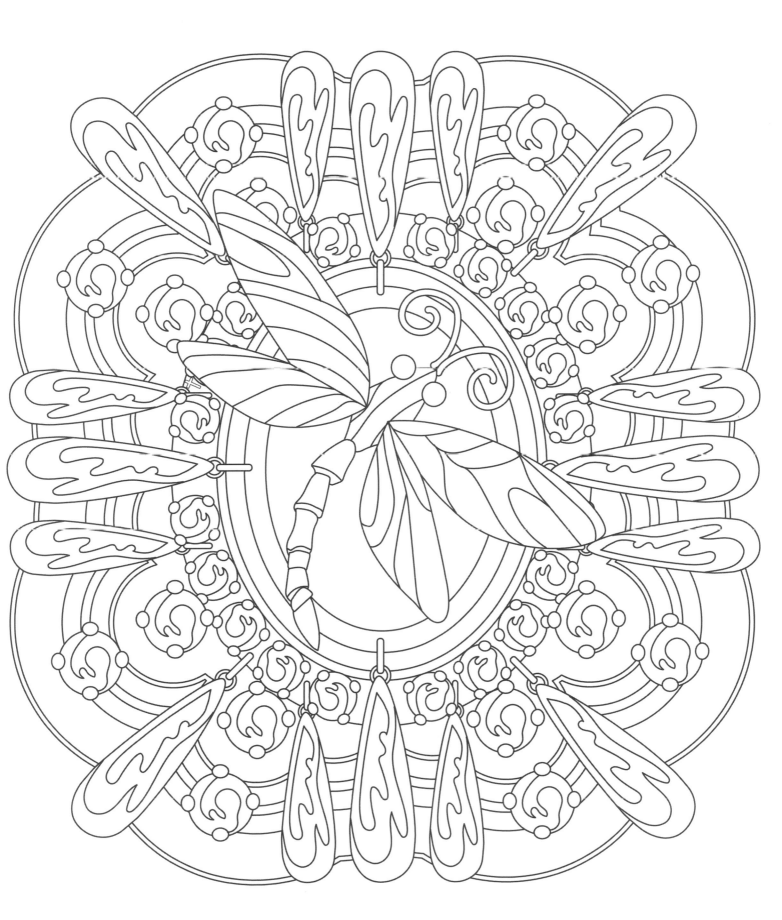

Be careful for nothing; but in every thing by prayer and supplication with thanksgiving let your requests be made known unto God.

Philippians 4:6

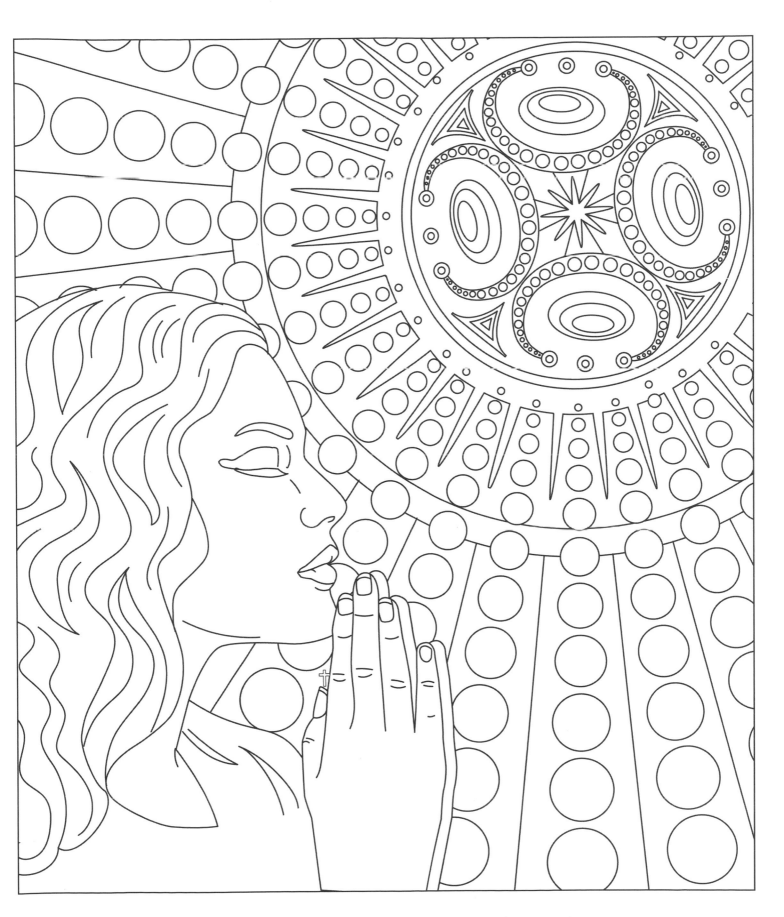

Therefore I say unto you, What things soever ye desire, when ye pray,
believe that ye receive [them], and ye shall have [them].
Mark 11:24

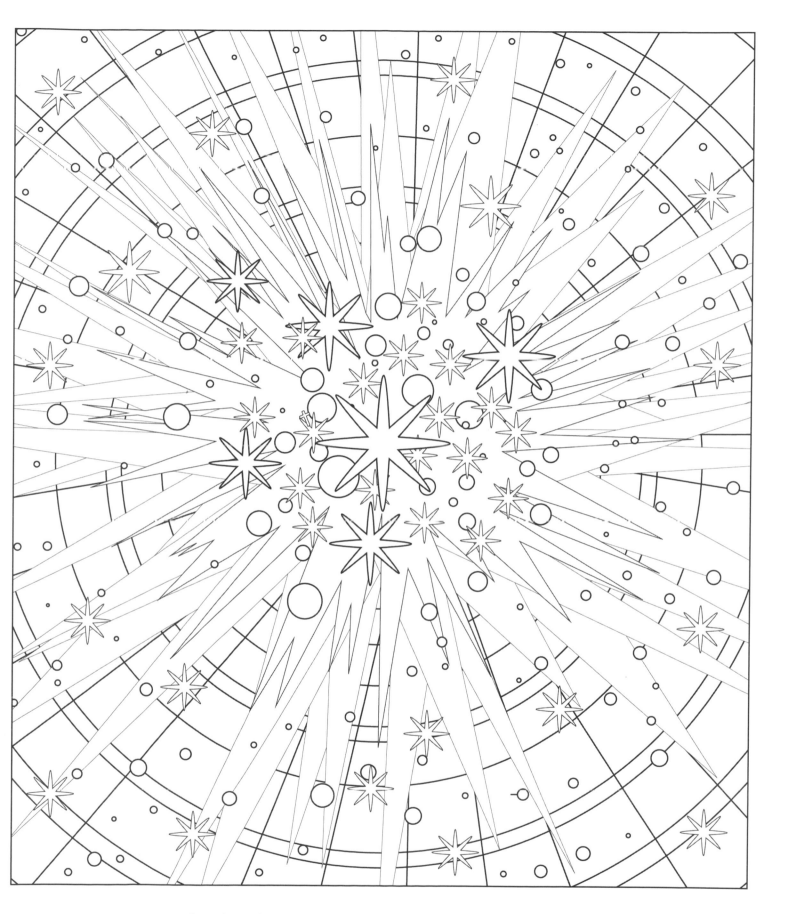

For God so loved the world, that he gave his only begotten Son,
that whosoever believeth in him should not perish, but have everlasting life.

John 3:16